A Gift of Friendship:

From:

Dedication

These photographs are dedicated to the Amish in my desire to create a visual legacy of their beautiful simplicity.

I also dedicate this book to the Clinic for Special Children, a not-for-profit organization, which is dedicated to preventing the devastating effects of metabolic genetic diseases on the Amish children. For more information contact: The Clinic for Special Children, 535 Bunker Hill Road, Strasburg, Pa. 17579

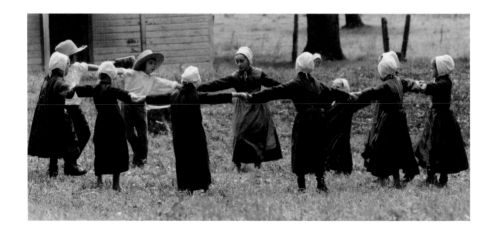

The Gift of Friendship

FEATURING THE AMISH PHOTOGRAPHY OF
BILL COLEMAN

RONNIE
SELLERS
PRODUCTIONS
PORTLAND, MAINE

To get the full value of joy,
you must have somebody
to share it with.

Mark Twain

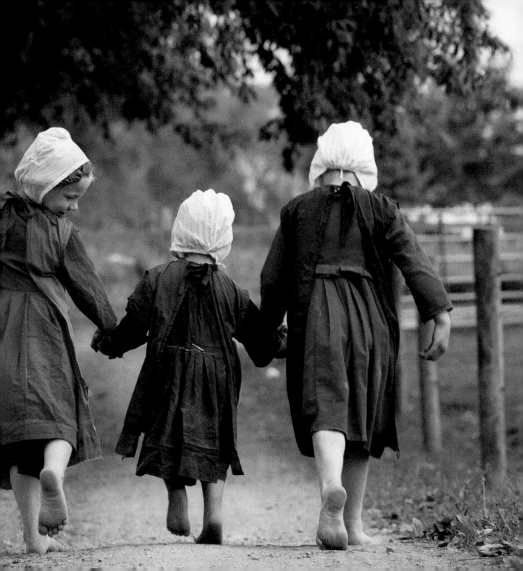

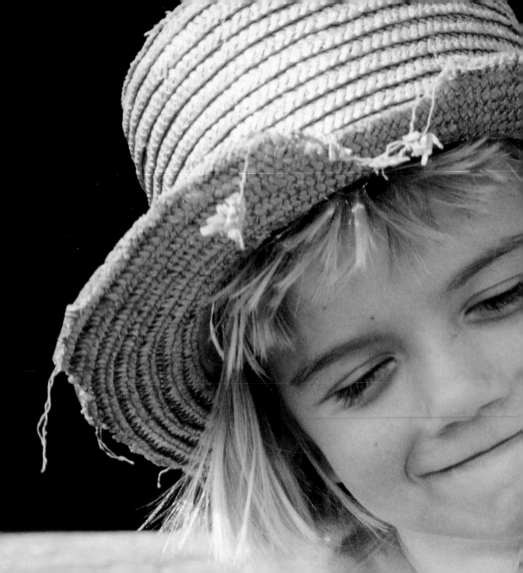

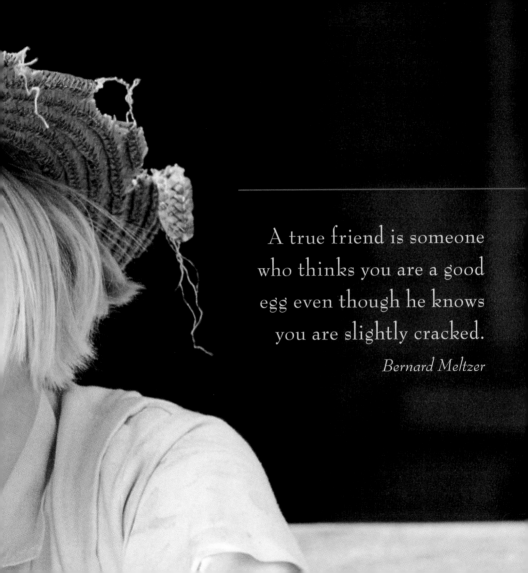

A true friend is someone
who thinks you are a good
egg even though he knows
you are slightly cracked.

Bernard Meltzer

Laughter is not at all a bad beginning for a friendship, and it is by far the best ending for one.

Oscar Wilde

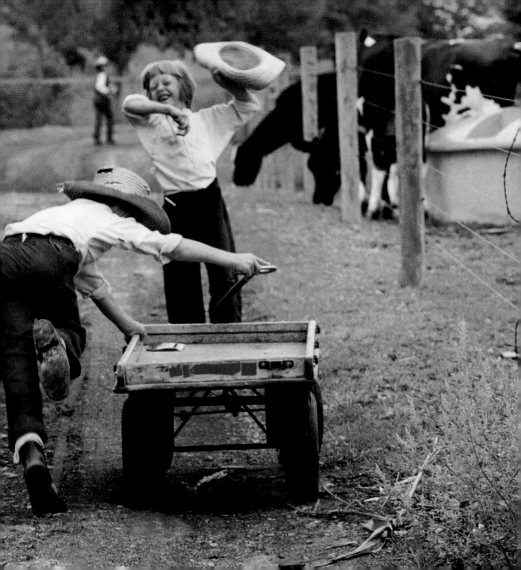

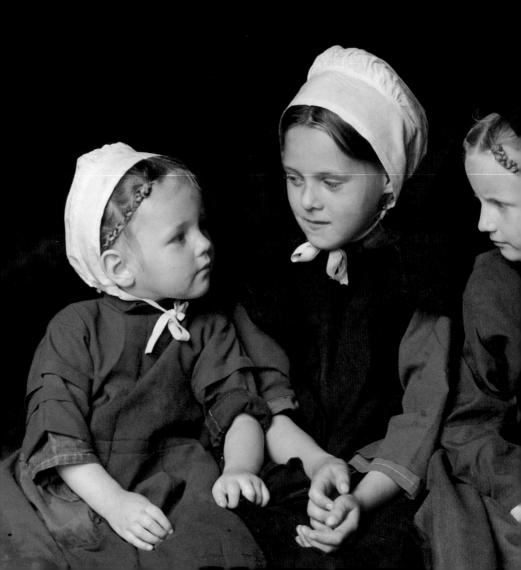

Friendship is born at that moment when one person says to another, "What! You, too? I thought I was the only one."

C.S. Lewis

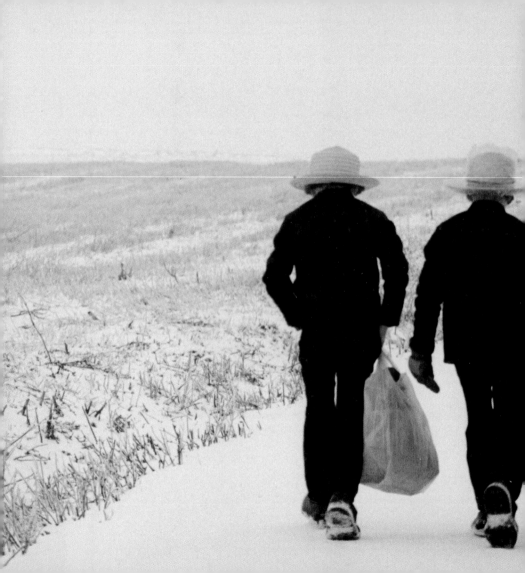

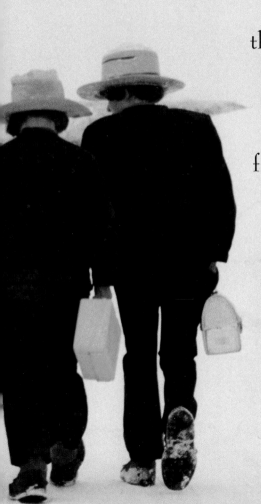

Friendship is the hardest thing in the world to explain. It's not something you learn in school. But if you haven't learned the meaning of friendship, you really haven't learned anything.

Muhammad Ali

A smile is the light in your window that tells others there's a caring, sharing person inside.

Denis Waitley

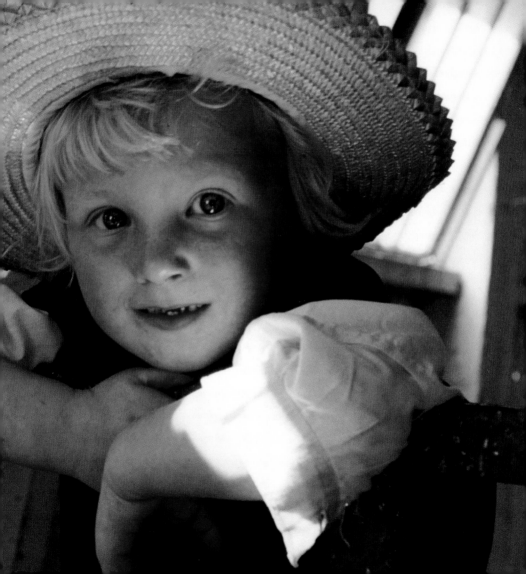

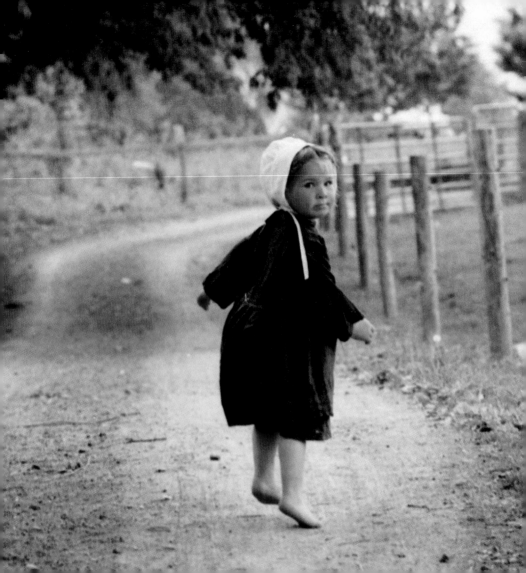

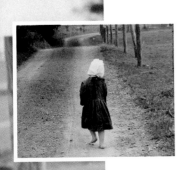

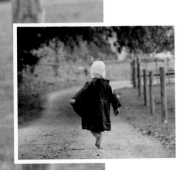

Go often to the house of
thy friend, for weeds
choke the unused path.

Ralph Waldo Emerson

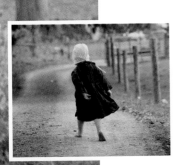

17

You cannot do a kindness
too soon, for you never know
how soon it will be too late.

Ralph Waldo Emerson

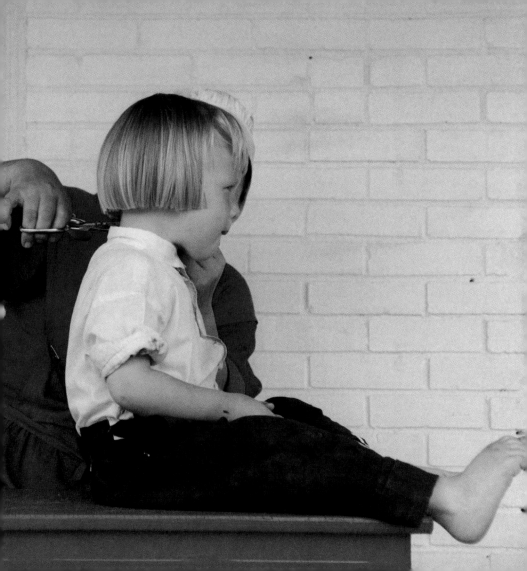

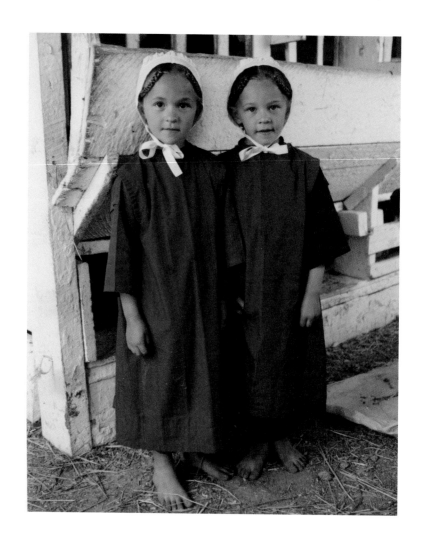

What is a friend? A single soul in two bodies.

Aristotle

A friend is a gift you give yourself.

Robert Louis Stevenson

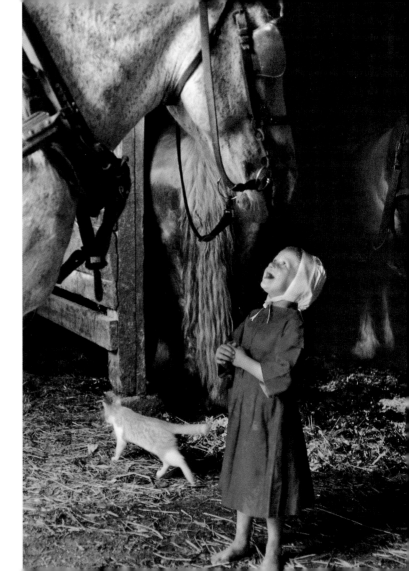

A circle is round, it has
no ends. That is how long
I want to be your friend.

Author unknown

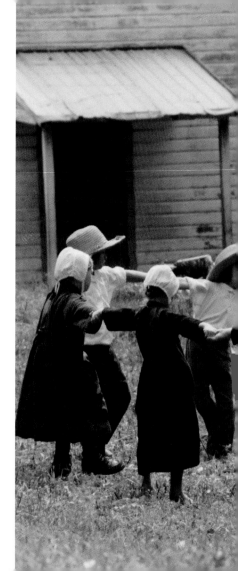

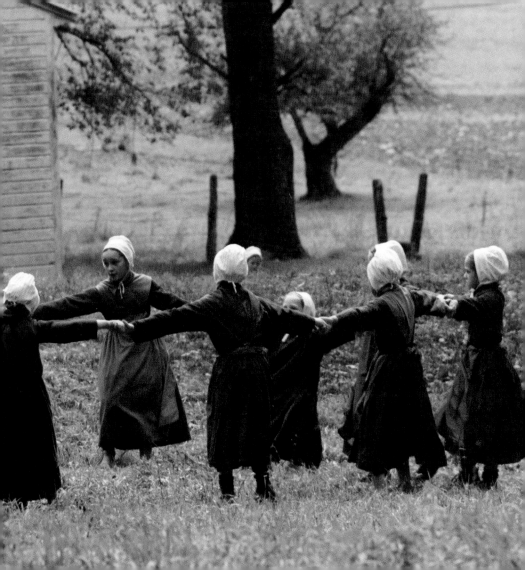

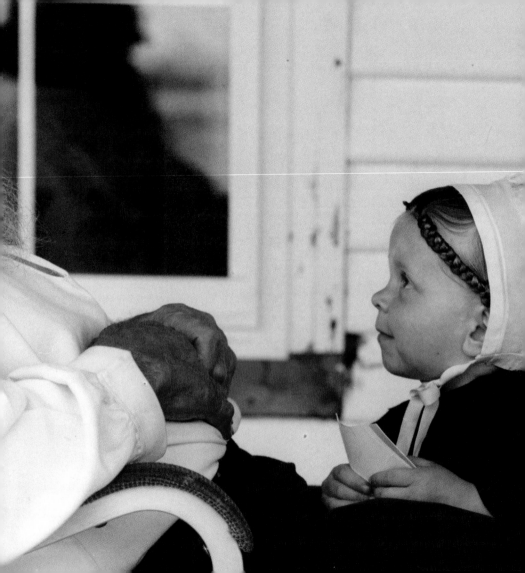

Too often we underestimate the power
of a touch, a smile, a kind word,
a listening ear, an honest compliment,
the smallest act of caring,
all of which have the potential
to turn a life around.

Leo Buscaglia

All of mankind agree that
friendship is one of the
few things in the world
truly useful.

Cicero

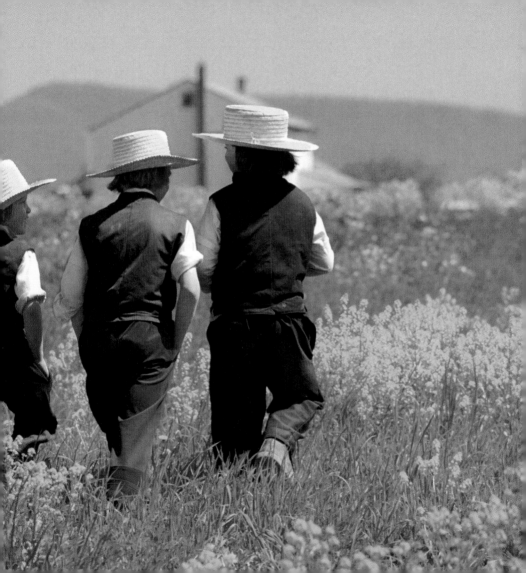

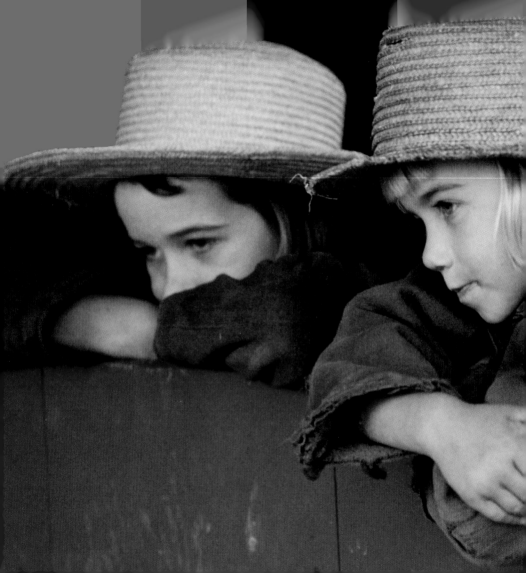

I have friends in overalls
whose friendship I would not swap
for the favor of kings of the world.

Thomas Edison

Lots of people want to ride with you in the limo, but what you want is someone who will take the bus with you when the limo breaks down.

Oprah Winfrey

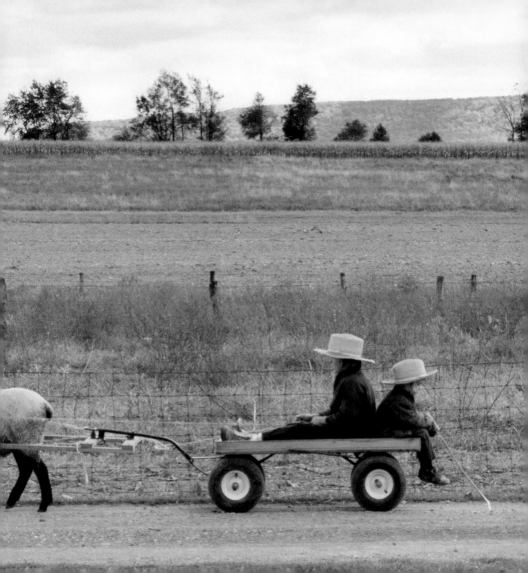

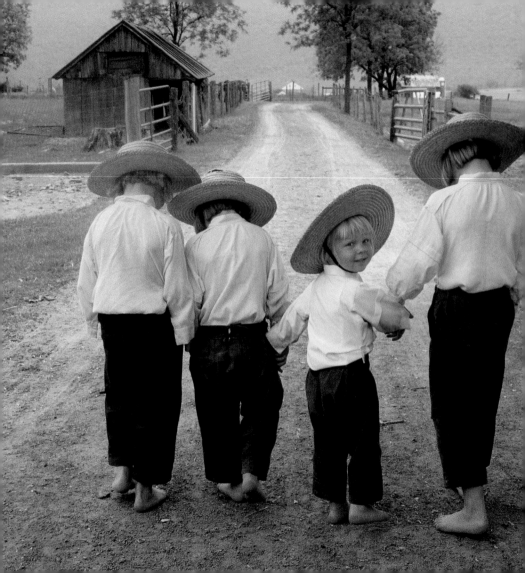

Remember, we all stumble,
every one of us. That's why it's a
comfort to go hand in hand.

Emily Kimbrough

A friend is, as it were, a second self.

Cicero

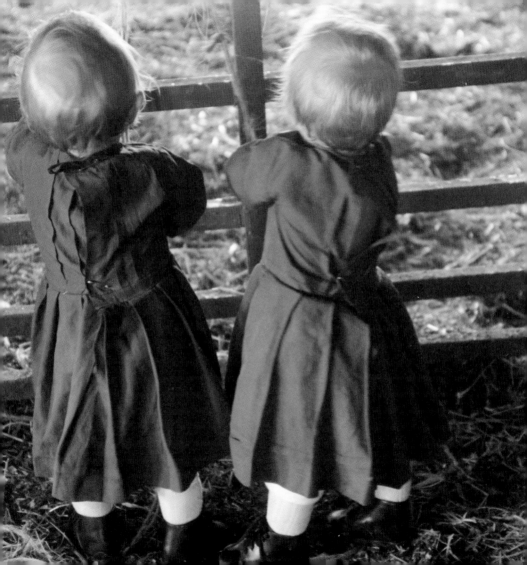

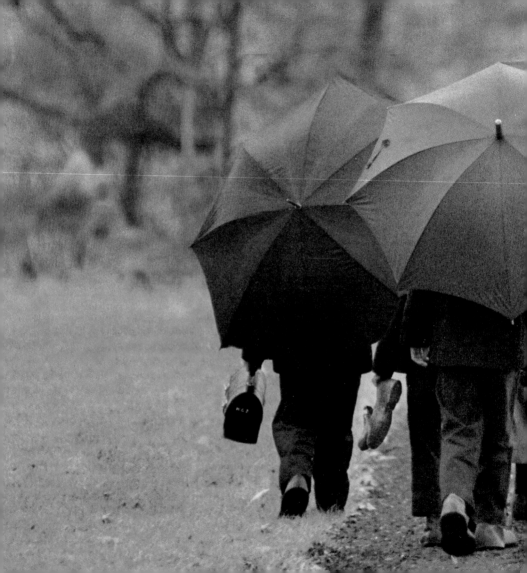

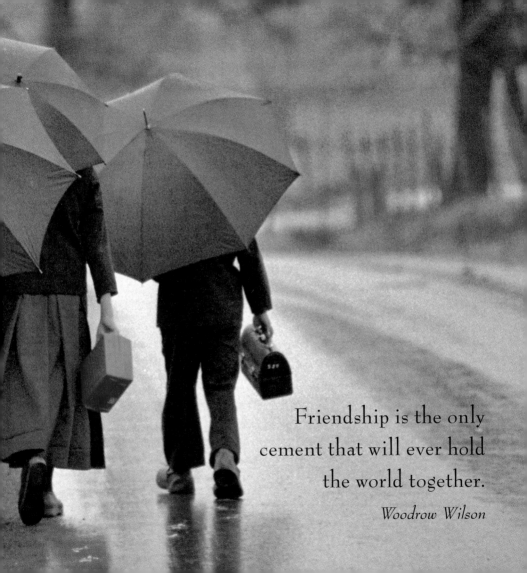

Friendship is the only
cement that will ever hold
the world together.

Woodrow Wilson

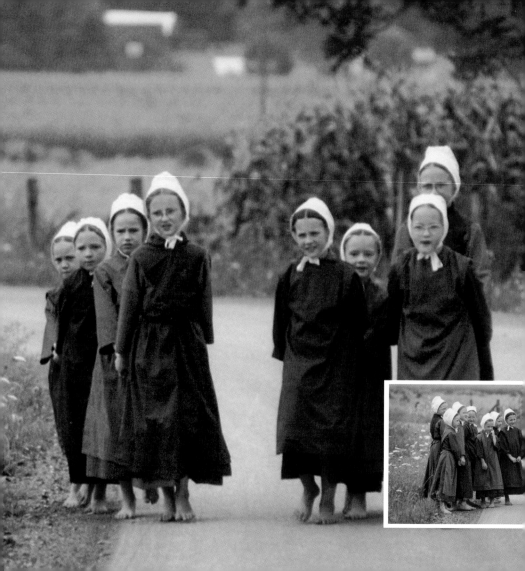

I cannot even imagine where I would be today were it not for that handful of friends who have given me a heart full of joy. Let's face it, friends make life a lot more fun.

Charles R. Swindoll

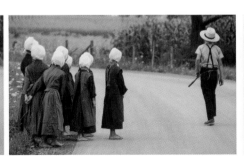
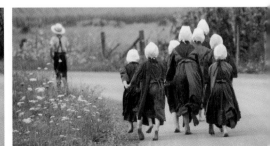

My best friend
is the one who
brings out the
best in me.

Henry Ford

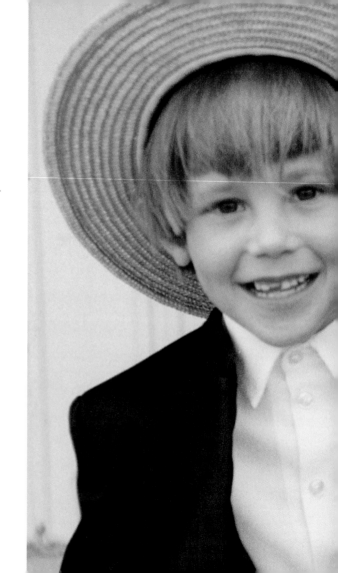

42

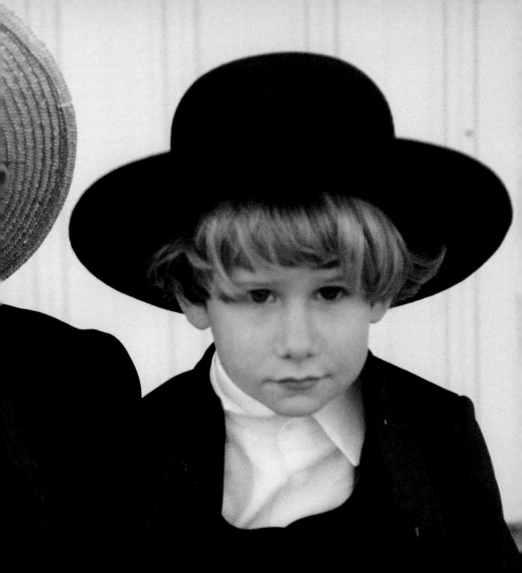

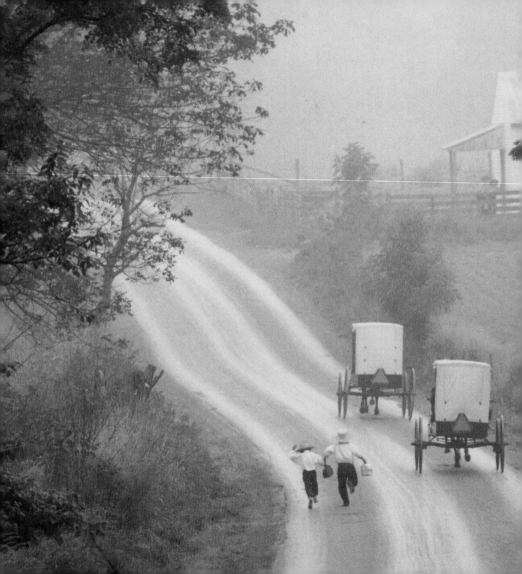

Ah, how good it feels!
The hand of a friend.

Henry Wadsworth Longfellow

45

Piglet sidled up to Pooh from behind.
"Pooh!" he whispered.
"Yes, Piglet?"
"Nothing," said Piglet, taking Pooh's paw.
"I just wanted to be sure of you."

A. A. Milne

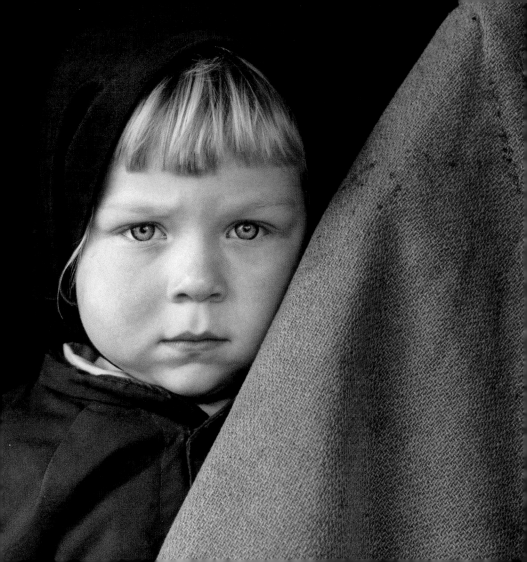

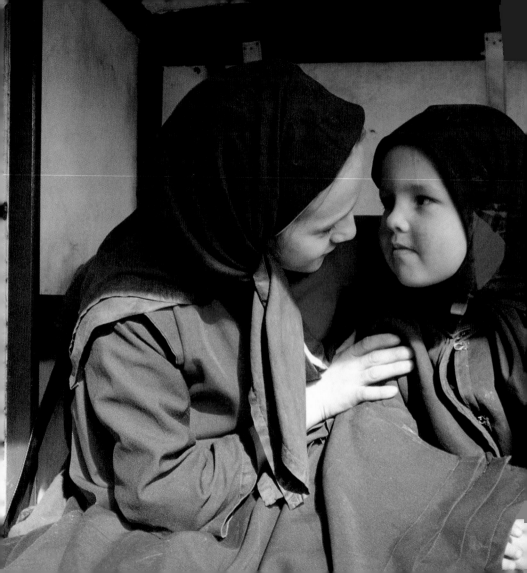

When I forget who I am,
I depend on you to remind me.

Author unknown

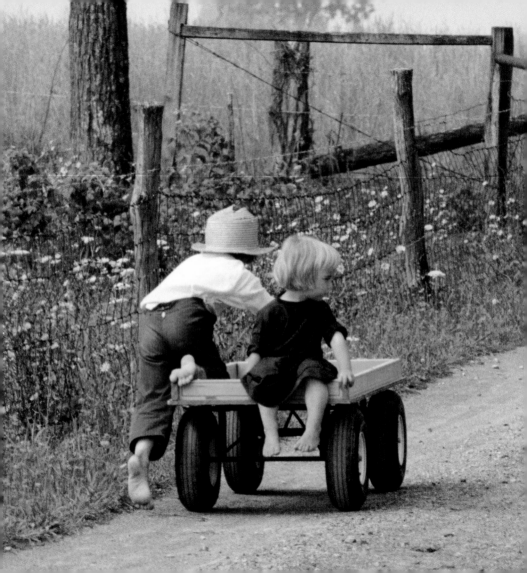

A real test of friendship is: Can you literally do nothing with the other person? Can you enjoy together those moments of life that are utterly simple? They are the moments people look back on and remember as their most sacred experiences.

Eugene Kennedy

I'll lean on you and you lean on me and we'll be okay.

Dave Matthews

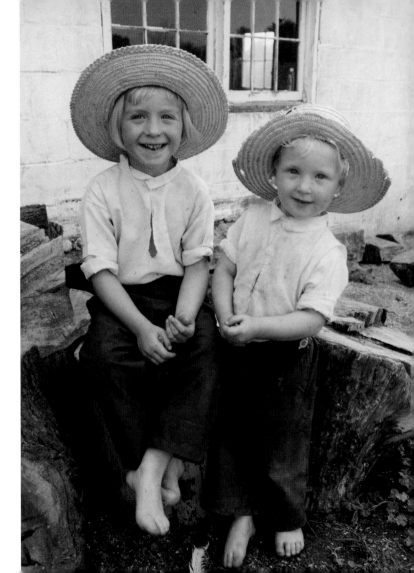

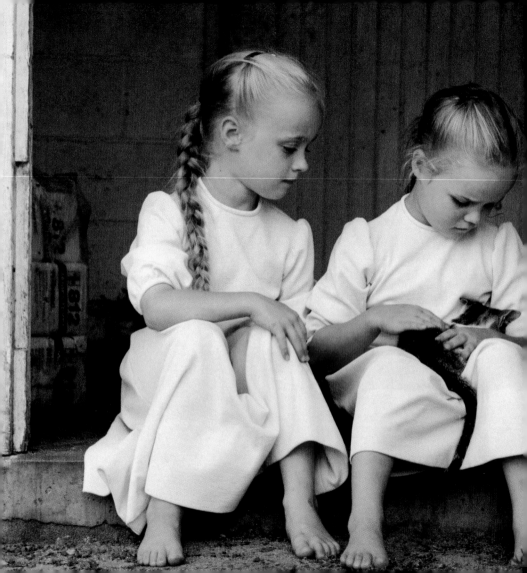

In the end, its the little things that matter; they add up to the priceless, thrilling magic found only in a friend.

Elizabeth Dunphy

Be who you are and say what you feel because those who mind don't matter and those who matter don't mind.

Dr. Seuss

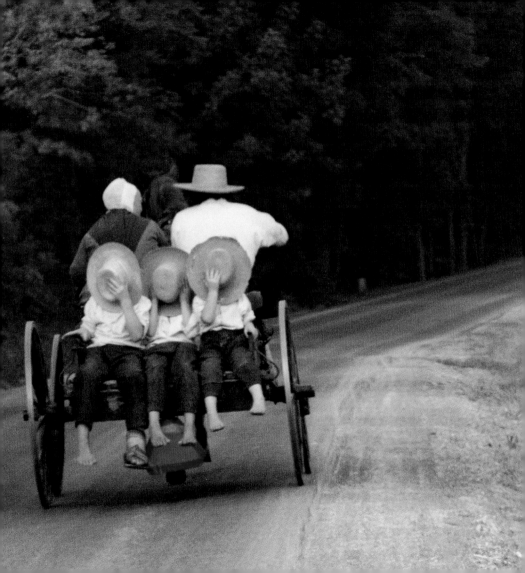

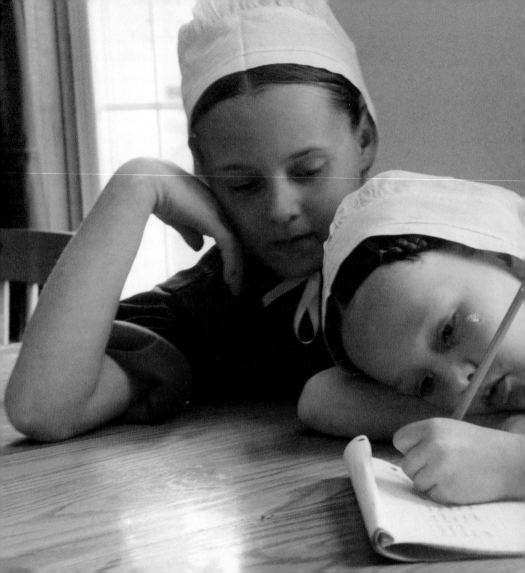

Friendship is a sheltering tree.

Samuel Taylor Coleridge

"Are we going to be friends forever?" asked Piglet.
"Even longer," Pooh answered.

A. A. Milne

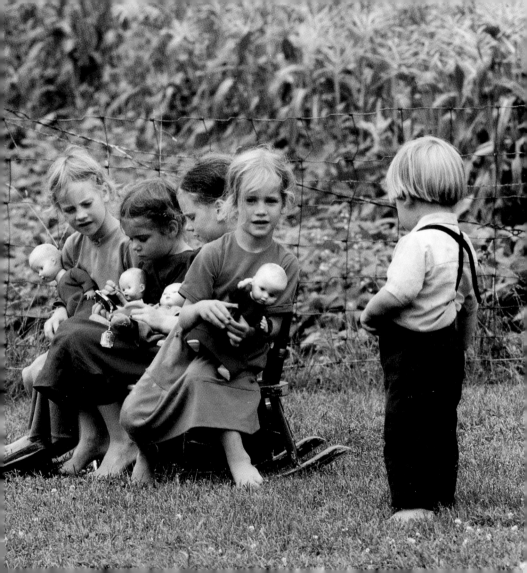

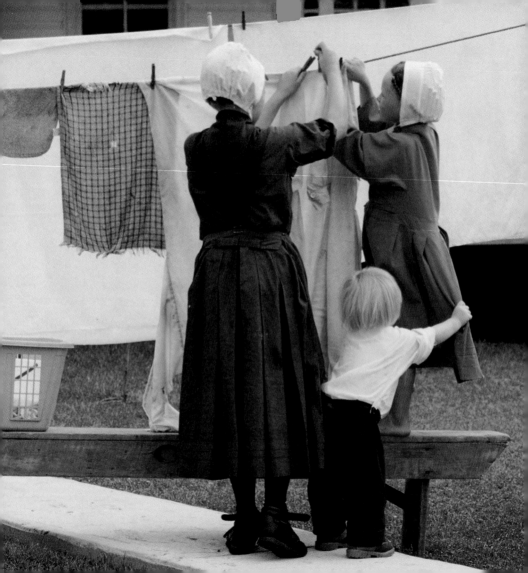

Life's most urgent question is:
What are you doing for others?

Martin Luther King, Jr.

Strangers are really friends
waiting to happen.

Author unknown

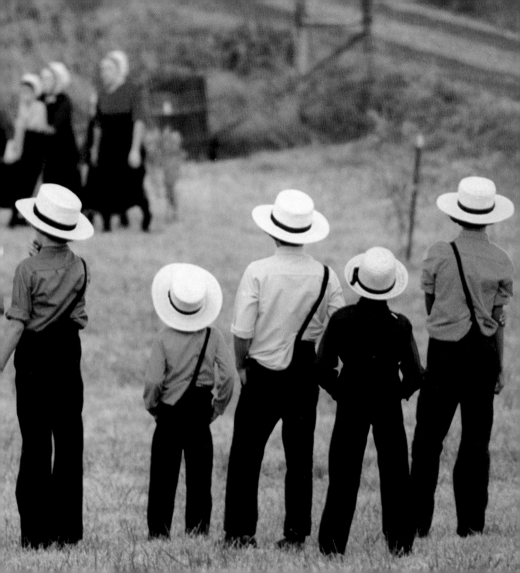

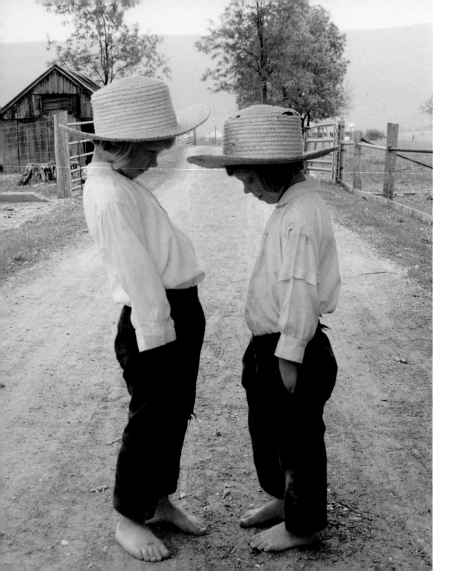

How rare and wonderful is that flash of a moment
when we realize we have discovered a friend.

William E. Rothschild

The simplicity of being appreciated
is the best gift of all.

Author unknown

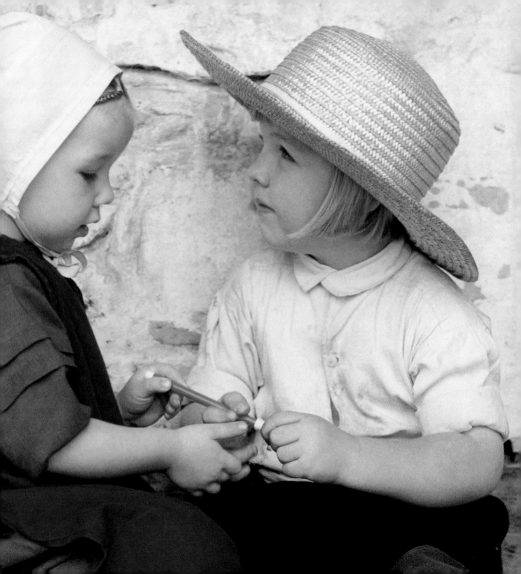

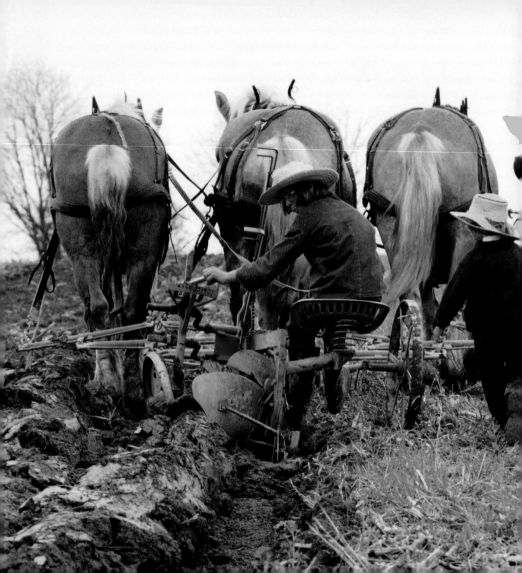

A true friend is someone who is there for you when he'd rather be anywhere else.

Len Wein

Those who bring sunshine
into the lives of others
cannot keep it from
themselves.

Sir James M. Barrie

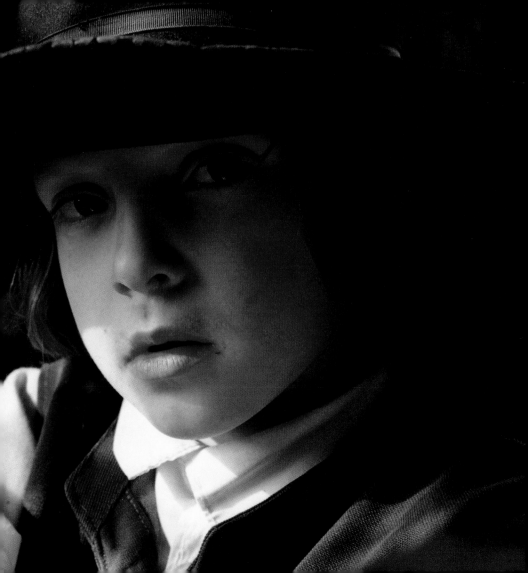

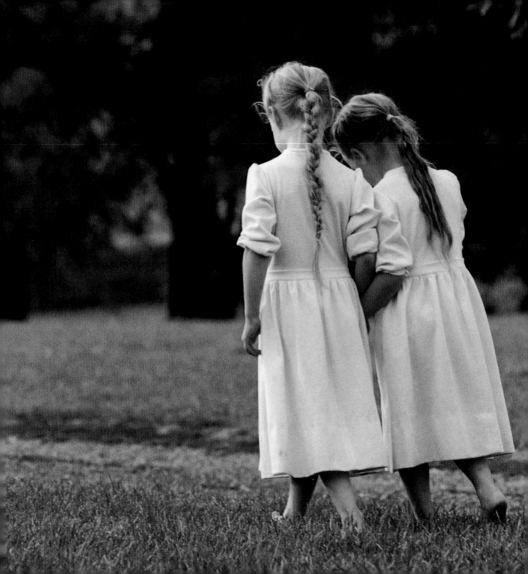

We have been friends together
in sunshine and in shade.

Caroline Sheridan Norton

Only your real friends will tell you when your face is dirty.

Sicilian proverb

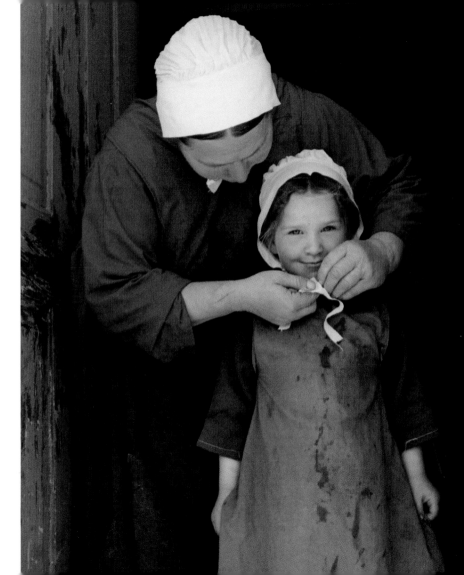

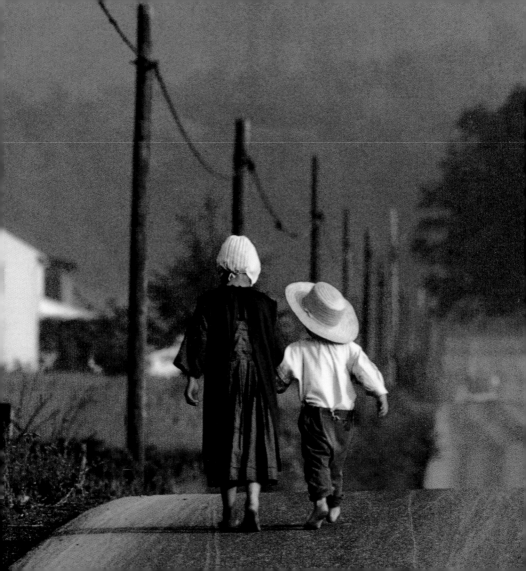

Walking with a friend in the dark is better than walking alone in the light.

Helen Keller

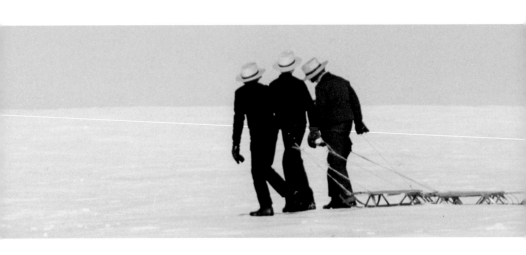

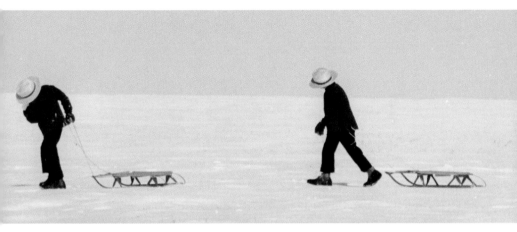

I do not wish to treat friendships daintily, but
with the roughest courage. When they are real,
they are not glass threads or frostwork,
but the most solid things we know.

Ralph Waldo Emerson

Whoever is happy will
make others happy, too.

Mark Twain

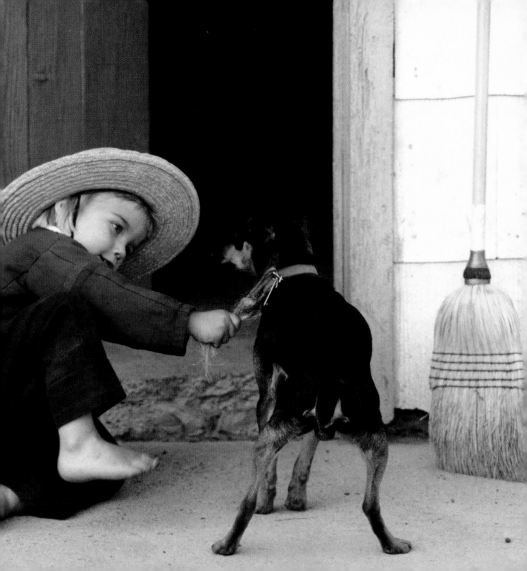

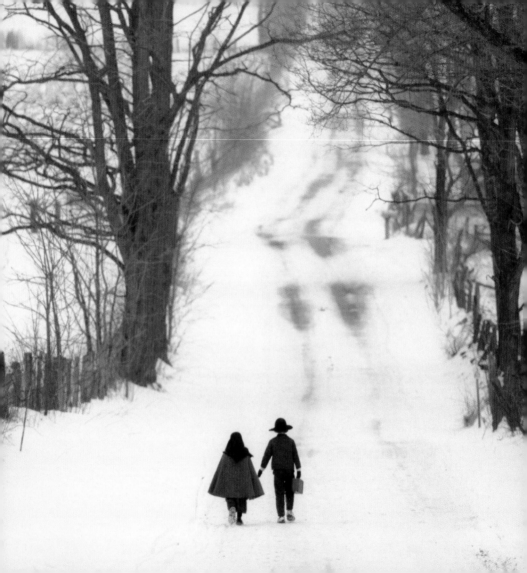

Some people come into our lives and leave footprints on our hearts, and we are never ever the same.

Flavia Weedn

Promise you won't forget me,
because if I thought you would,
I'd never leave.

A. A. Milne

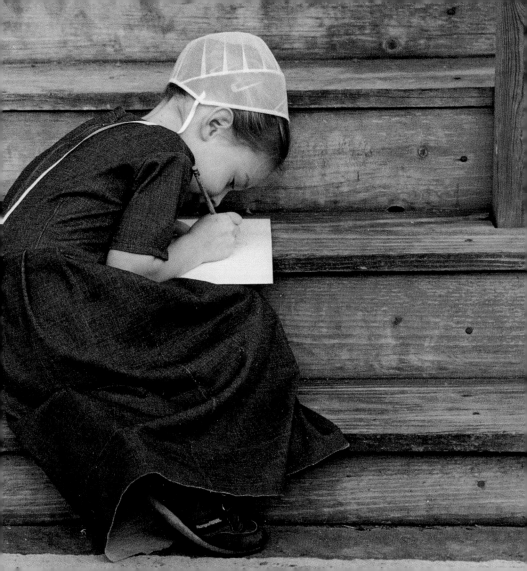

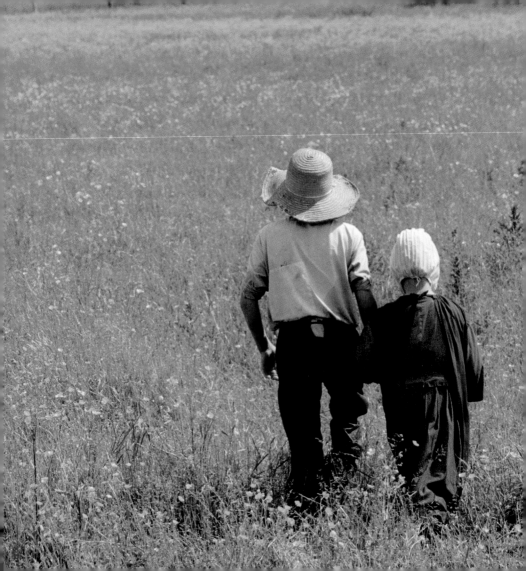

Kindness in words creates confidence.
Kindness in thinking creates
profoundness. Kindness in
giving creates love.

Lao Tzu

May there always be work for your hands to do. May your purse always hold a coin or two. May the sun always shine on your windowpane. May a rainbow be certain to follow each rain. May the hand of a friend always be near you. May God fill your heart with gladness to cheer you.

Irish blessing

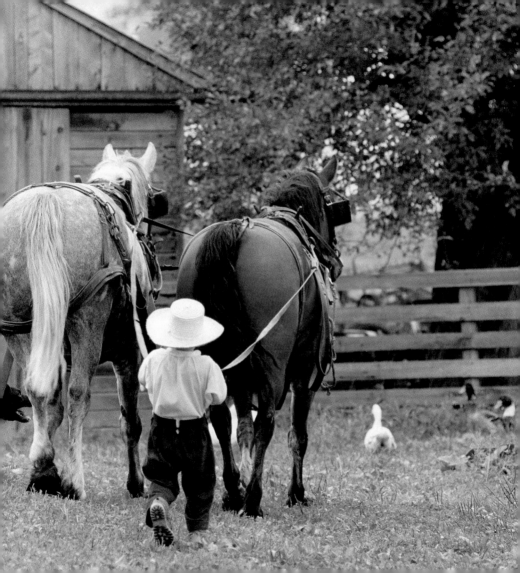

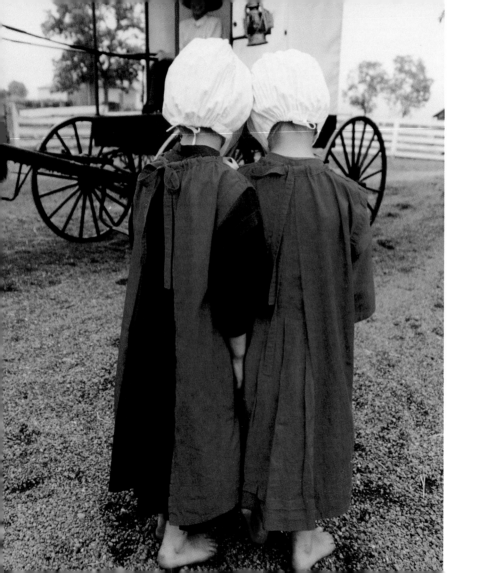

For it was not into my ear you whispered,
but into my heart. It was not me
you kissed, but my soul.

Judy Garland

Celebrate the happiness that friends are always giving. Make every day a holiday and celebrate just living!

Amanda Bradley

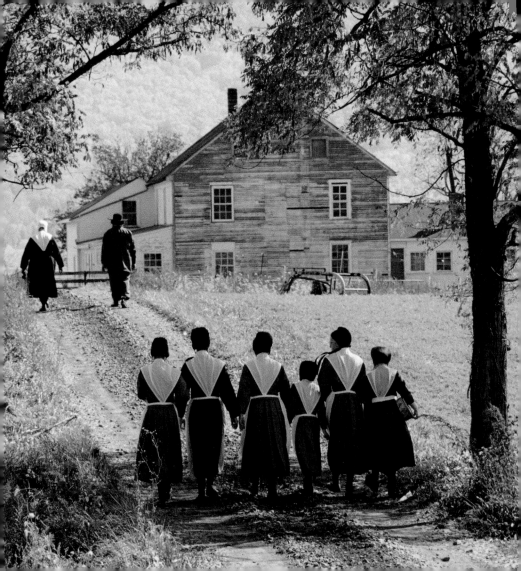

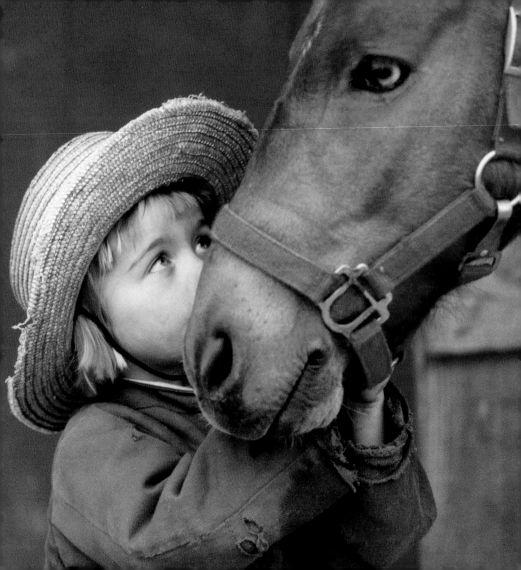

The world would be so lonely,
in sunny hours or gray,
without the gift of friendship
to help us every day.

Hilda Brett Farr

God gives us our relatives,
and we thank God we can
choose our friends.

Ethel Watts Mumford

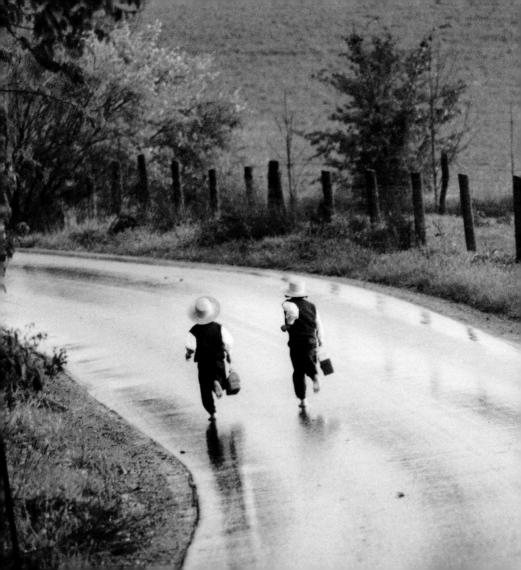

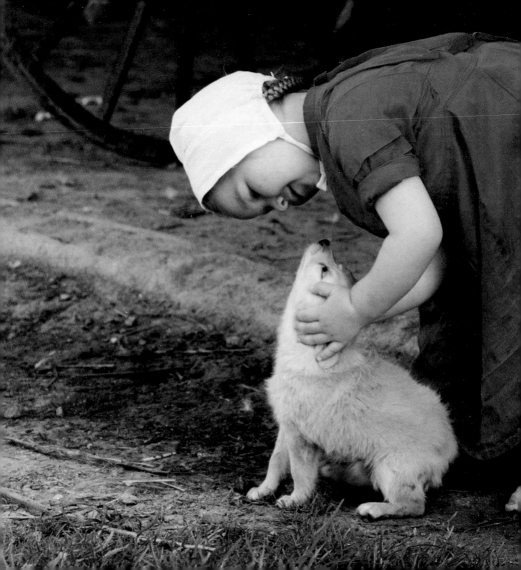

There is nothing better than the encouragement of a good friend.

Katharine Butler Hathaway

Surround yourself only with people who are going to lift you higher.

Anonymous

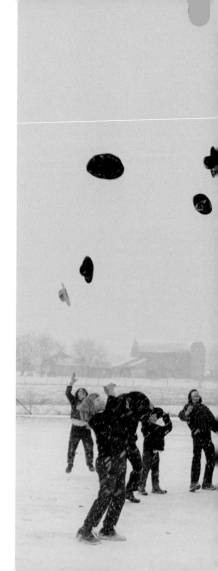

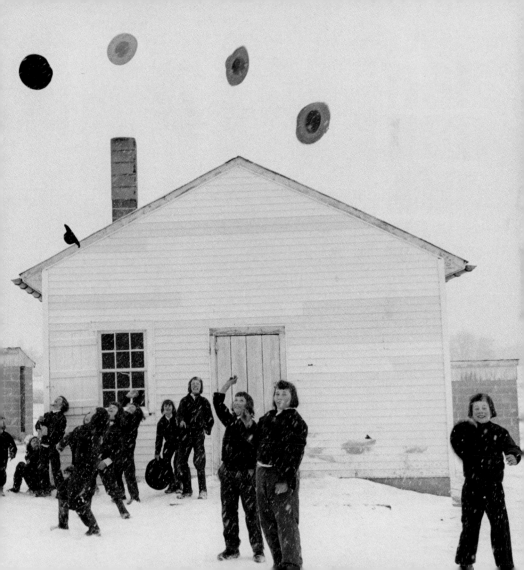

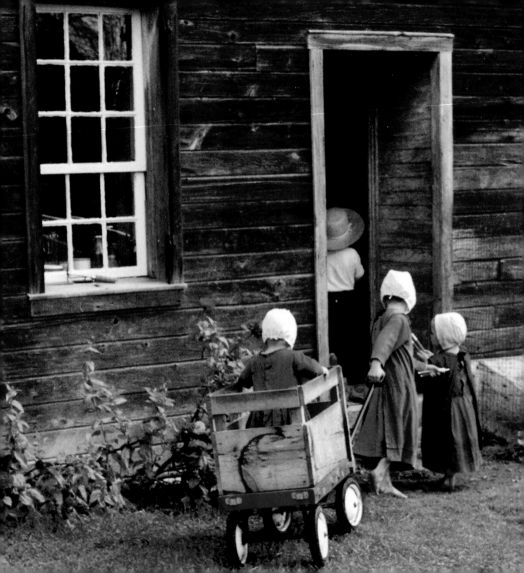

Good friends are
good for your health.

Irwin Sarason

How lucky I am to have known someone who was so hard to say good-bye to.

Anonymous

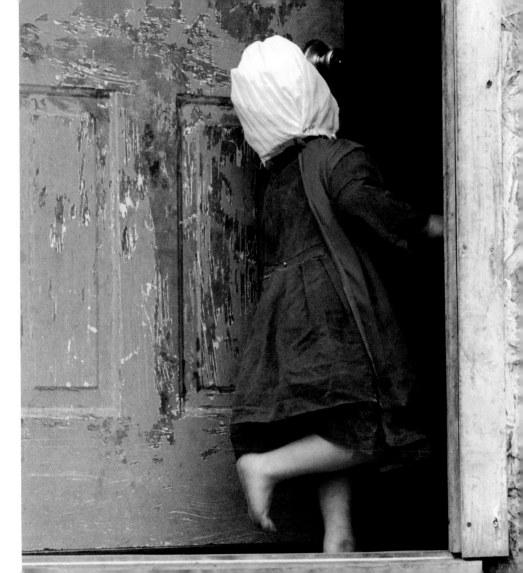

Afterword

Thirty-three years ago I began an Amish Odyssey that has kept me traveling back to a small and all-but-unknown Amish village where only a few of the 90-plus families have come to tolerate me and my camera. The images of the young people in this book are representative of this odyssey of mine.

My interactions with these unique and wonderful people, their values and their way of living, have quietly altered my own values and perspective on life — all for the better.

The Amish believe in their children and know that good habits start at an early age. They teach their young ones skills, socialization, virtues, and most importantly, the keystone to their culture — cooperation, and friendship.

Each time they raise a barn, for example, selfless cooperation with each other is dramatically demonstrated for their children. It reinforces their belief that anything worthwhile is truly built on a foundation of friends helping one another to achieve an essential goal. The Amish trust that friendship is meant to last a lifetime, a lifetime of nurturance, cooperation, and love. The images in this book of friendship will give you an intimate look at children who flourish in and cherish this special bond.

~ *Bill Coleman*

Credits

Cover image: Sisters Three; Dedication page: *'Round the Rosie*

pp. 4-5 *Sisters Three*; pp. 6-7 *Henry*; pp. 8-9 *Glee*; pp. 10-11 *Learning*; pp. 12-13 *Brothers Four*; pp. 14-15 *Young Titus*; pp. 16-17 *Nancy*; pp. 18-19 *Once a Month*; p. 20 *Peas in a Pod*; p. 23 *Lindi and Friend*; pp. 24-25 *'Round the Rosie*; pp. 26-27 *Of Beards and Braids*; pp. 28-29 *Little Men*; pp. 30-31 *Dan and Henry*; pp. 32-33 *Ewe Haul*; pp. 34-35 *Brothers Four II*; pp. 36-37 *Anna's Twins*; pp. 38-39 *Lunchbox Brigade*; pp. 40-41 *Pursuit*; pp. 42-43 *Ben & Jeremiah*; pp. 44-45 *Almost Late II*; pp. 46-47 © A.A. Milne from the book *Winnie the Pooh*, photo *Enos II*; pp. 48-49 *Sisterly Advice*; pp. 50-51 *Brothers*; p. 53 *Double Dose*; pp. 54-55 *Sisters II*; pp. 56-57 *See No Evil*; pp. 58-59 *Teaching*; pp. 60-61 © A.A. Milne from the book *Winnie the Pooh*, photo *Eight Dolls & A Brother*; pp. 62-63 *Little Helper*; pp. 64-65 *All Sizes All Shapes*; p. 66 *Negotiations*; pp. 68-69 *Sharing II*; pp. 70-71 *Four Horses & Three Boys*; pp. 72-73 *Raymond*; pp. 74-75 *Sisters Two*; p. 77 *Daily Ritual*; pp. 78-79 *Firmly*; pp. 80-81 *Sled Pullers*; pp. 82-83 *Friendly Persuasion*; p. 84 © Flavia Weedn from the book *Forever*; photo *Of Things To Come*; p. 86-87 © A.A. Milne from the

book *Winnie the Pooh*; photo *Ella Mae*; pp. 88-89 *A Meadow Walk*; pp. 90-91 *Just Like Dad*; p. 92 *Not Twins from Behind*; pp. 94-95 *Sunday*; p. 96 *Henry In Love*; pp. 98-99 *Almost Late III*; pp. 100-101 *Puppy Love*; pp. 102-103 *Rural Frisbees IV*; pp. 104-105 *Round Up* IV; p. 107 *Nancy*.

Published by Ronnie Sellers Productions, Inc.

Copyright © 2005 Ronnie Sellers Productions, Inc.
Photography © 2005 Bill Coleman
All rights reserved.

Publishing Director: Robin Haywood
Production Editor: Mary Baldwin
Cover Design: Patti Urban

P.O. Box 818, Portland, Maine 04104
For ordering information:
Phone: 1-800-625-3386
Fax: (207) 772-6814
Visit our Web site: www.rsvp.com
E-mail: rsp@rsvp.com

ISBN: 1-56906-582-9
Library of Congress Control Number: 2004097389

Printed in Singapore